An Introduction to the

MUSEUM AND SC

Introduction by Abram Lerner

DIRECTOR, THE HIRSHHORN MUSEUM AND SCULPTURE GARDEN

Hirshhorn

ULPTURE GARDEN

SMITHSONIAN INSTITUTION

Harry N. Abrams, Inc., Publishers, New York

Fourth Printing

Standard Book Number: 8109-2051-4
Library of Congress Catalogue Card Number: 74-11204
Published by HARRY N. ABRAMS, INCORPORATED, NEW YORK, 1974
Printed and bound in Japan

Introduction

JOSEPH H. HIRSHHORN's catholicity has provided us with an unusual record of American painting from about 1870 on, European and American sculpture from the middle of the nineteenth century on, and European painting of the past three decades. These constitute the major categories of our inaugural exhibition.

Although painting and sculpture from Mr. Hirshhorn's collection frequently appeared in important national and international exhibitions and his collecting career was well known in the art world, it was a major show of 444 sculptures at the Solomon R. Guggenheim Museum in New York, in 1962, that focused sudden public interest on the collector and his collection.

Mr. Hirshhorn's career as art collector spans a period of forty years. He recollects that his interest in art began when, as a boy, he discovered reproductions of popular Salon masters in an insurance company calendar. He pasted them on his bedroom wall and spent hours studying their colors and edifying sentiments. This fateful experience remained etched in his memory and, perhaps because of it, the first paintings he acquired as a successful young businessman were by William-Adolphe Bouguereau, Joseph Israels, Edwin Henry Landseer, and Jean-Jacques Henner.

But an unrelenting curiosity, strengthened by visits to museums and galleries, inevitably led to the revelation of modern art which was a liberating experience, ending his quest for the past. By natural temperament a man of the present, he found that modern art touched him deeply and yielded aesthetic experiences which he had not previously known.

By the late 1930s, Mr. Hirshhorn had disposed of his Salon heroes and substituted such modern painters as Monet, Cézanne, Degas, Renoir, Chagall, Rouault, Jules Pascin, and André Masson. He turned decisively to the contemporary scene, and eventually gave up his Impressionist and School of Paris works. This action can be understood in retrospect as a change of emphasis, for Renoir, Degas, Matisse, and Picasso are represented in the collection by sculpture, and paintings by Pascin and Masson have, happily, been reinstated.

The 1930s and 1940s appear to have been decisive years in Mr.

Hirshhorn's collecting career. His earlier taste for the past and its reassuring nostalgia was subtly challenged by the realities of the Depression years. From visits to galleries and museums, and friendships formed with artists, Mr. Hirshhorn began to develop that inspired greed for art which has dominated so much of his life. He would leave a business meeting and rush to an exhibition or an artist's studio, or would suddenly descend on a gallery and buy several works with a certainty and speed rarely encountered by dealers accustomed to endless deliberation and reflection. In the early forties, together with a small group of fellow collectors, he would spend every Saturday visiting the galleries on Fifty-seventh Street in New York. His enthusiasm, decisiveness, and bargaining skill became legendary.

It was on one of his visits to the ACA Gallery in New York, in 1945, that I first met Mr. Hirshhorn. I had been working in the gallery for a very short time. It was summer, and there were few visitors. Suddenly a man hurried in, scanned the exhibition, and inquired about several paintings. He bought four works in short order and departed as suddenly as he had entered. After this initial encounter I saw him often. Frequently I accompanied him to galleries and found myself happily involved in the excitement these visits generated. I ventured to suggest particular exhibits for him to see and was pleased when he acquired something I had praised. He never bought what he did not personally respond to, no matter who recommended it. If anything, "expert" advice seemed to turn him off. He would listen, and perhaps it might have its effect later, but for the moment he would trust his own feelings. Though we frequently disagreed on individual artists or works of art, over the next twenty-five years our differences were insignificant in the face of his general ardor and responsiveness. I was particularly taken by his enthusiasm for the young artists, his faith in their talent, and his ability to adjust quickly to their vision of the world. What seemed to matter most was their unique ability to excite his interest and admiration.

During the late 1930s he acquired his first work of sculpture, a stone carving by the American John Flannagan. Although he did not begin to buy sculpture avidly until almost a decade later, this initial purchase must have been rooted in a fertile, if still dormant, appreciation of structural form and concrete imagery. What began casually in the thirties became a passion in the forties and has remained so to the present.

By the late 1950s, the nature of the collection had been determined. The paintings were primarily American, with a broad sampling of European art of the past three decades, while the sculpture was international and covered a greater time span. Warehouse space became indispensable for the overflow from Mr. Hirshhorn's home and office in New York, and his house, office, and hotel suite in Canada. The

collection had in a sense taken over, its incredible growth creating inevitable problems.

In 1956, I was appointed full-time curator, and I established headquarters in Mr. Hirshhorn's New York office at 65 Broadway. It was a fascinating combination of business office, gallery, and warehouse. Paintings covered the walls, and sculpture occupied tables and floor. Steel bins held the overflow in another room. When it became evident that I required separate quarters, I found space in a charming building at the corner of Sixty-seventh Street and Madison Avenue (now replaced by a faceless office building). The "art office," as Mr. Hirshhorn referred to it, had many functions, among them the usual ones of cataloguing, handling correspondence and requests for loans, overseeing storage facilities, clearing foreign shipments, maintaining proper insurance levels, and so forth. But it was also a halfway house between Mr. Hirshhorn's business office and the art galleries. Here he could pause to look at his most recent acquisitions, examine new paintings and sculpture which I had gathered for his consideration, set up meetings with artists and dealers, and schedule visits to galleries. Within a short time the office was packed with new acquisitions, and one had to tread carefully for fear of bumping into a canvas or toppling a piece of sculpture.

This office was followed by a somewhat larger one on Sixty-eighth Street which also filled very quickly, despite the fact that we were constantly shipping items to the warehouse where we now occupied considerable space. Every so often Mr. Hirshhorn would accompany me to the warehouse. He always seemed a little surprised by the quantity of objects, but delighted in pulling paintings out of bins, handling the sculpture, and excitedly discussing individual works.

In 1961 Mr. Hirshhorn established a residence in Greenwich, Connecticut. The commodious scale of this country estate seemed to encourage and even accelerate his art buying. The spacious house—surrounded by inviting areas of flowerbeds, lawns, and stone walks—was quickly inundated with paintings and small sculpture. He placed large bronzes in the garden and on the lawns, and kept adding pieces for variety and contrast. His garden became one of the most exciting places in the United States in which to see modern sculpture. Over the years thousands of people have visited Greenwich, usually in groups organized by charitable and educational institutions.

One might say that Mr. Hirshhorn was unwilling or incapable of confining his acquisitions to a particular style or school; the breadth and variety of art was too appealing to be channeled into a specialty. From the beginning, he relied on his own sensibility and judgment to direct him to works of quality and interest. For example, Mr. Hirshhorn acquired

his first paintings by the New York School a decade after the new art had first appeared, but he savored color-field painting from its beginning.

Variety and scope were maintained, and, significantly, the purchase of an artist's works did not cease once he was represented in the collection. On the contrary, a positive reaction almost always guaranteed a sustained interest in an artist and the acquisition of additional works. This has provided important in-depth representation, making the collection extremely valuable for research and study.

It is difficult to say just when Mr. Hirshhorn realized that his collection had outgrown its private status. The question of its future was often raised between us, and it became clear that he felt its size and importance imposed a special responsibility on him to preserve it intact and to eventually give it to the public. Fate intervened in 1964, when official representations were made by the British Government to establish a museum for the collection in London. The offer was tempting for a variety of reasons, especially the prospect of establishing a museum which would in large part consist of twentieth-century American painting and sculpture, the first representation of its kind in a foreign capital. Its effect on the dissemination and appreciation of American art abroad could not be overestimated, a fact that was not lost on Mr. Hirshhorn. At about the same time, representations were also made from official quarters in Zurich, Florence, and Tel Aviv. In New York, Governor Nelson A. Rockefeller suggested that the collection be housed in its own museum on the campus of the State University at Purchase, where it would serve the student body and the visiting public.

All these overtures were carefully considered. Then, late in 1964, Mr. Hirshhorn was approached by Dr. S. Dillon Ripley, Secretary of the Smithsonian Institution, who suggested that Mr. Hirshhorn present his collection to the United States, under the aegis of the Smithsonian. A site on the Mall in Washington, D.C., was suggested for a museum building and sculpture garden. The intercession of President Lyndon B. Johnson made Mr. Hirshhorn's choice inevitable. In 1966 an agreement was reached between Mr. Hirshhorn and the Smithsonian, and that same year Congress enacted legislation creating the Hirshhorn Museum and Sculpture Garden.

Since its creation in 1846, the Smithsonian Institution has followed its founder's expressed wish that it serve as "an establishment for the increase and diffusion of knowledge among men." What has been referred to as the nation's "attic" is, in fact, the world's largest museum complex, including six art museums, four history and science museums, a national zoological park, and other facilities which reach out across the nation and the world. The Hirshhorn Museum and Sculpture Garden is proud to be a part of this distinguished establishment.

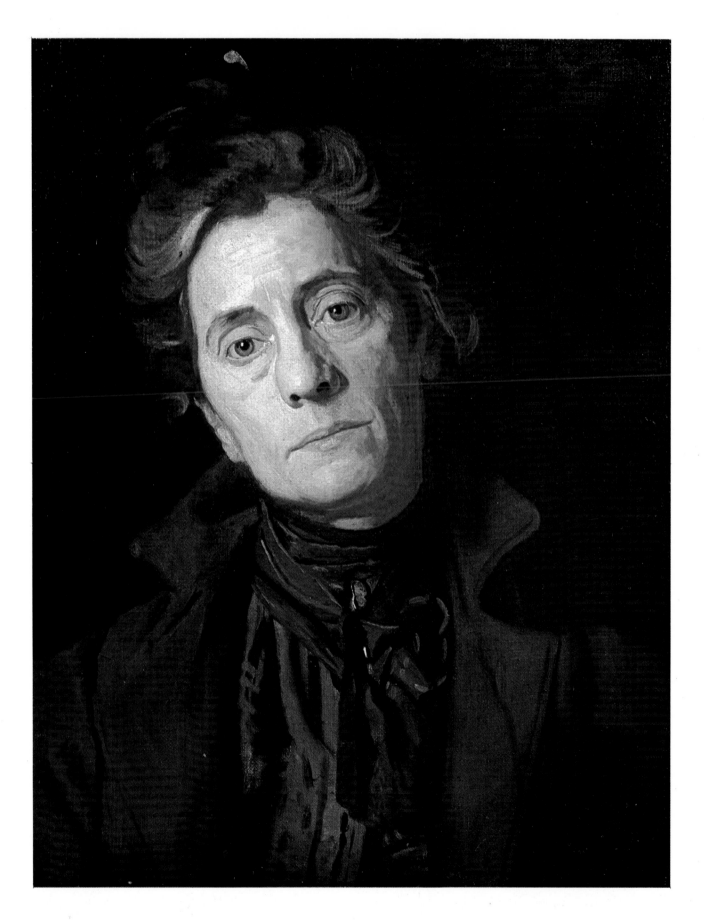

1. THOMAS EAKINS. *Mrs. Thomas Eakins.* c. 1899. Oil on canvas, 20 × 16″

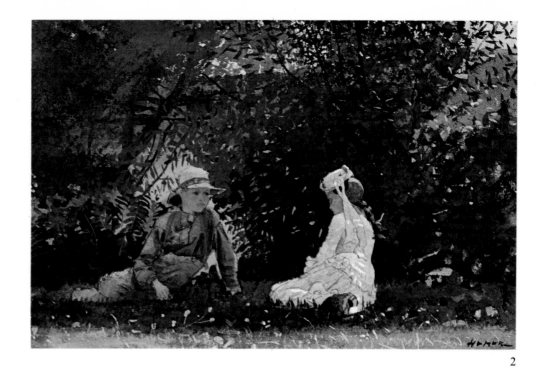

2

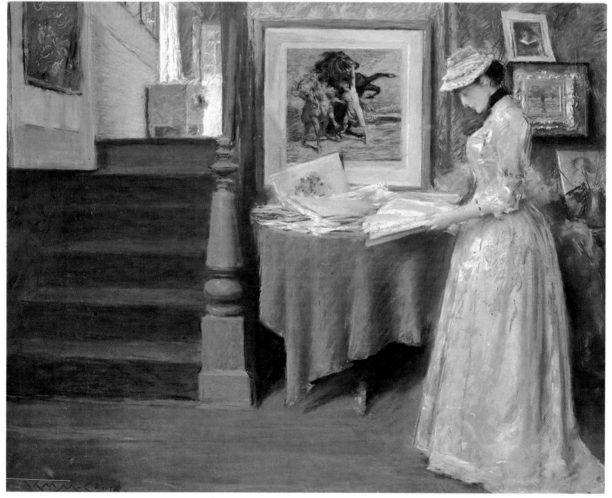

3

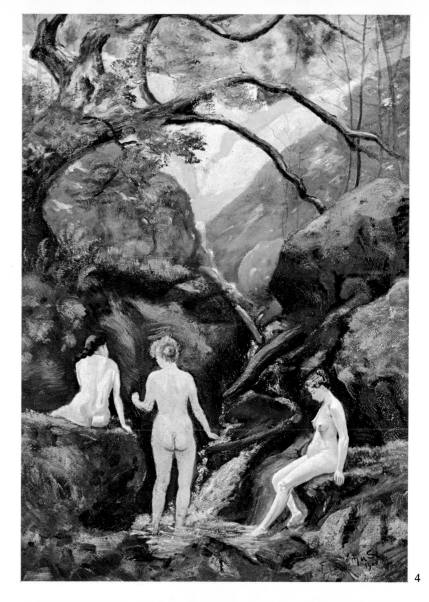

2. WINSLOW HOMER.
Scene at Houghton Farm. c. 1878.
Watercolor on paper, 7¼ × 11¼"

3. WILLIAM MERRITT CHASE.
*Interior: Young Woman Standing
at Table*. c. 1898.
Pastel on paper, 22 × 28"

4. LOUIS EILSHEMIUS.
Mountain Stream (Three Nudes
at a Mountain Creek). 1900.
Oil on canvas, 27½ x 19⅛"

5. MAURICE PRENDERGAST.
Beach at Gloucester. c. 1912–14.
Oil on canvas, 30⅝ × 43"

4

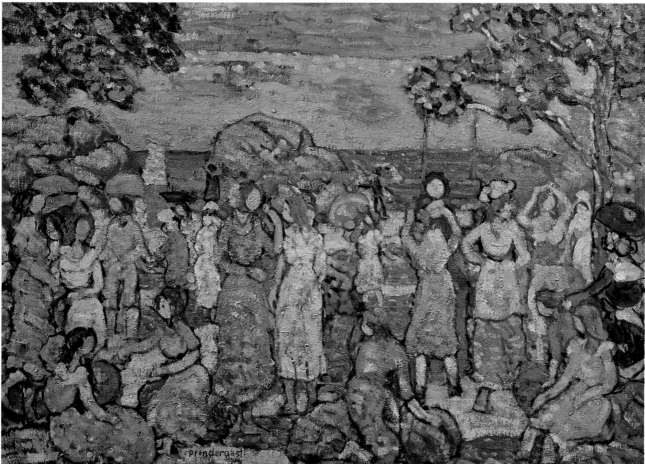

5

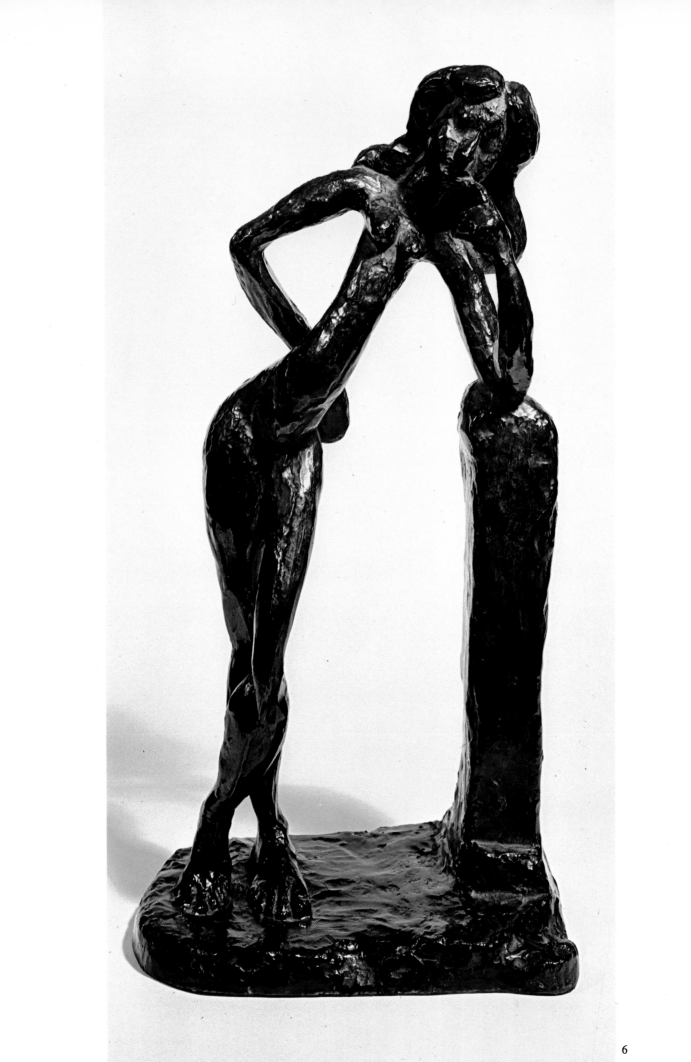

6

6. HENRI MATISSE. *La Serpentine*. 1909. Bronze, 22 × 11½ × 7½"

7. MARSDEN HARTLEY *Painting No. 47, Berlin*. 1914–15. Oil on canvas, 39¼ × 31½"

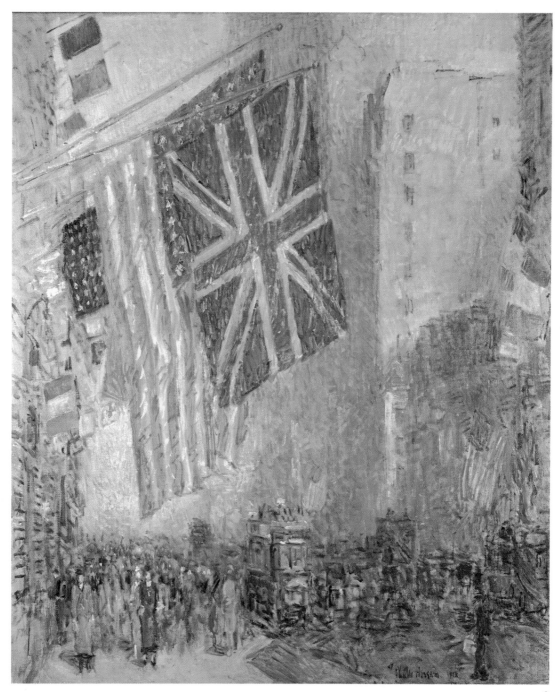

8

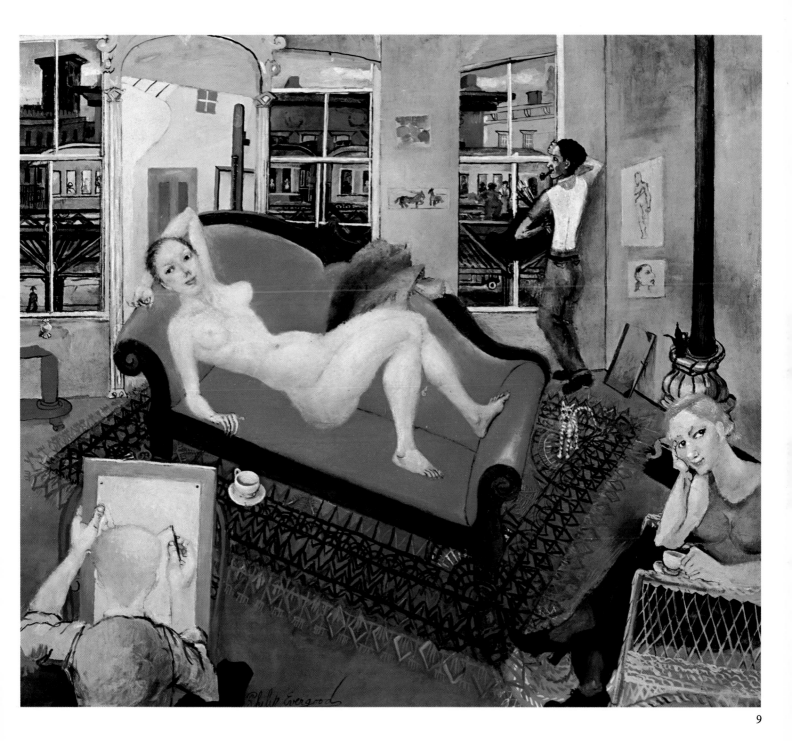

9

8. CHILDE HASSAM. *The Union Jack, New York, April Morn.* 1918. Oil on canvas, 37 × 20″

9. PHILIP EVERGOOD. *Nude by the El.* 1934. Oil on canvas, 38 × 43″

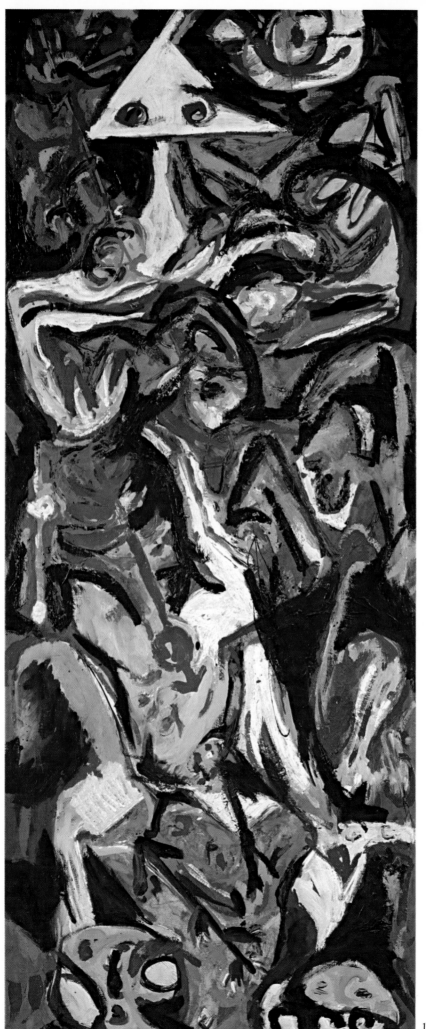

10. JACKSON POLLOCK.
Water Figure. 1945.
Oil on canvas, 71¾ × 29″

11. EDWARD HOPPER.
First Row Orchestra. 1951.
Oil on canvas, 31 × 40″

12. AD REINHARDT.
Number 90, 1952 (red). 1952.
Oil on canvas, 11 × 20′

10

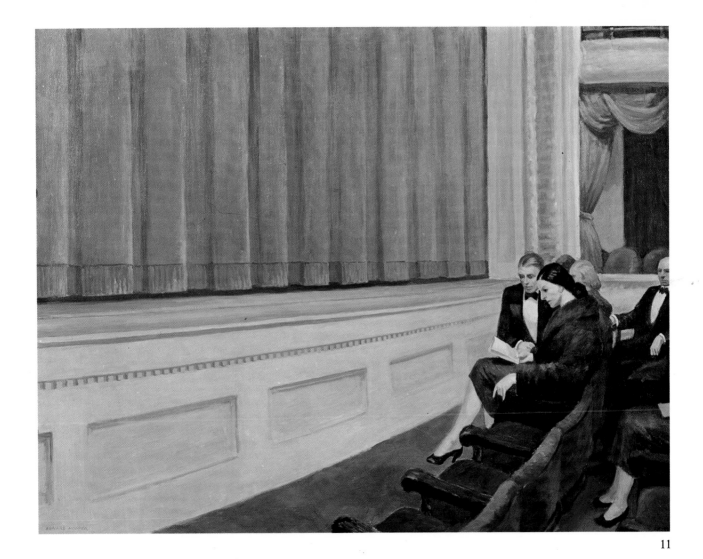

11

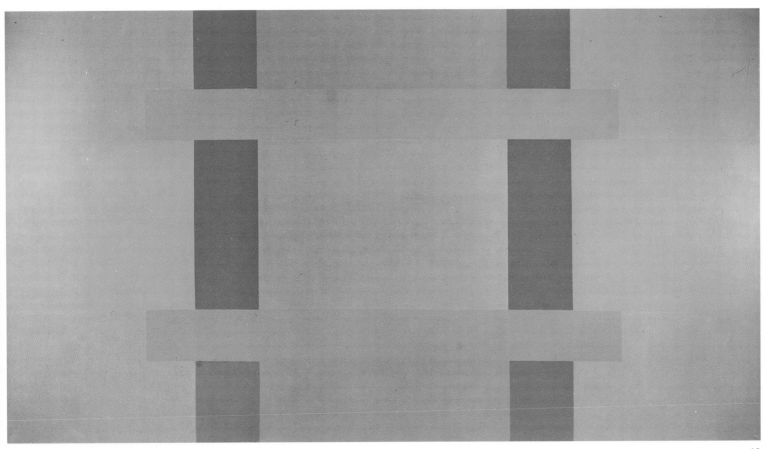

12

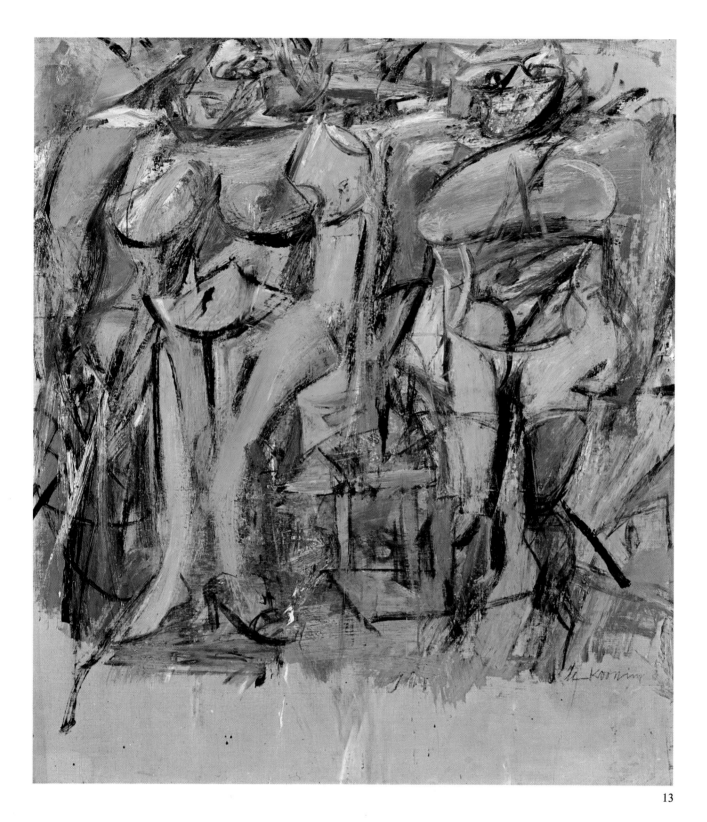

13

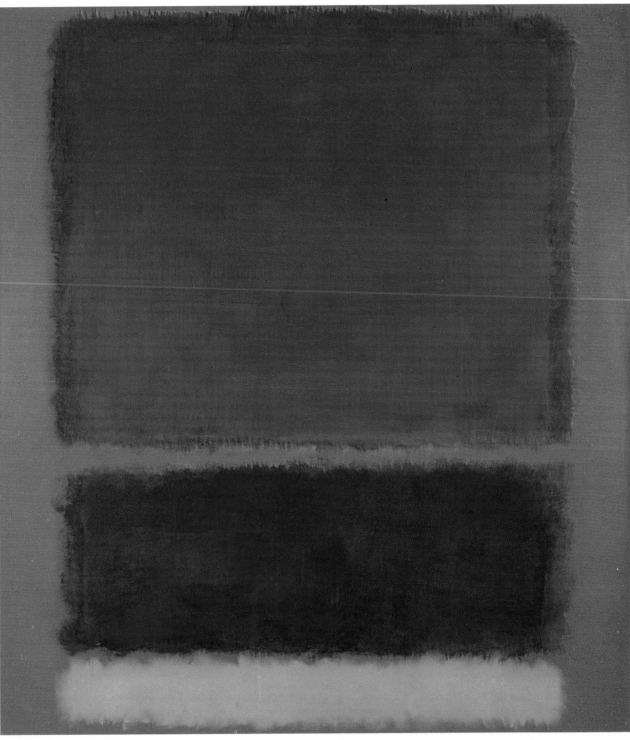

13. WILLEM DE KOONING. *Two Women in the Country*. 1954. Oil, enamel, and charcoal on canvas, 46 × 41"

14. MARK ROTHKO. *Blue, Orange, Red*. 1961. Oil on canvas, 90¾ × 81"

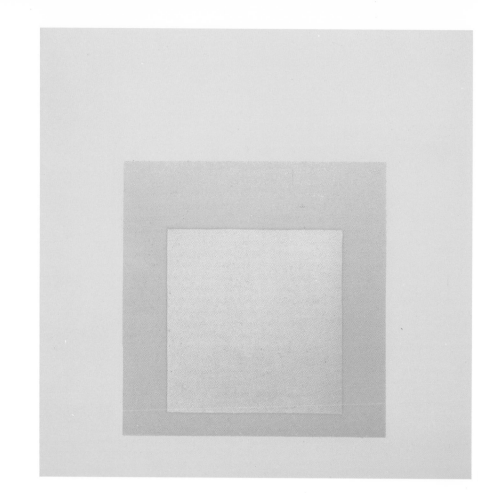

15

15. JOSEF ALBERS.
*Homage to the Square:
Chosen.* 1966. Oil on
Masonite, 48 × 48″

16. FRANK STELLA.
Darabjerd III. 1967.
Fluorescent acrylic on
canvas, 10 × 15′

17. HONORÉ DAUMIER.
Ratapoil. c. 1850, cast 1925.
Bronze, 17⅜ × 6½ × 7¼″

16

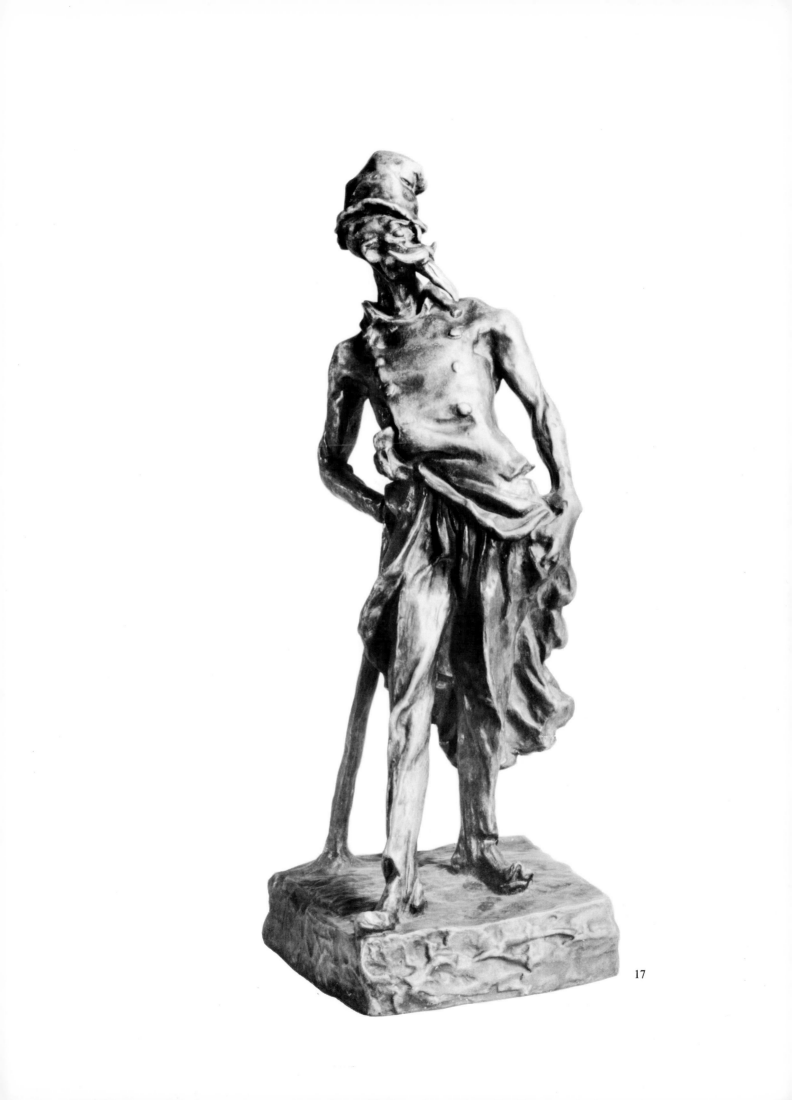

17

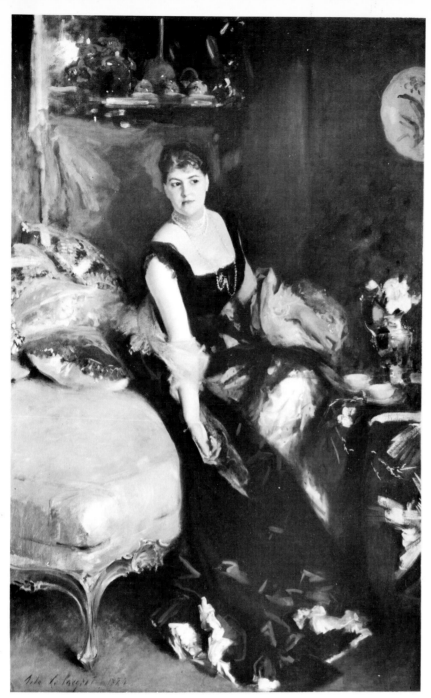

18

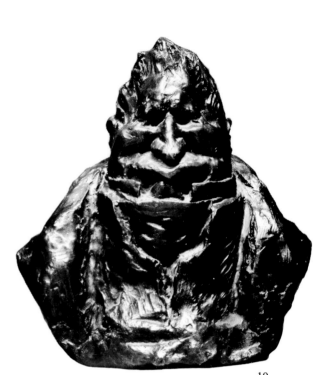

19

18. JOHN SINGER SARGENT.
Mrs. Kate A. Moore. 1884.
Oil on canvas, 70 × 44″

19. HONORÉ DAUMIER.
Podenas (The Malicious Man
of Importance). c. 1832–35,
cast 1929–52. Bronze,
8⅛ × 7⅞ × 5″

20. THOMAS EAKINS.
The Opening of the Fight. 1893,
cast 1969. Bronze
relief, 55 × 94″

20

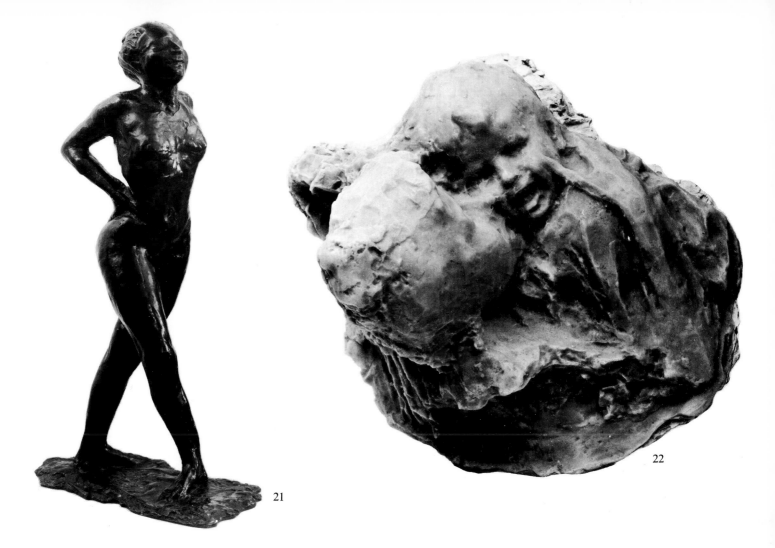

21

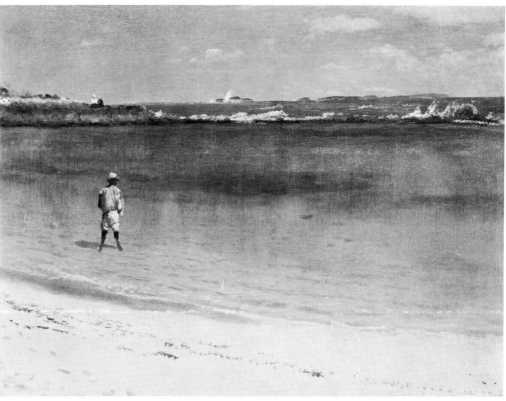

22

21. EDGAR DEGAS.
*Dancer at Rest, Hands
Behind Her Back,
Right Leg Forward.*
c. 1882–95, cast 1919–21.
Bronze, 17⅜ × 4⅞ × 10″

22. MEDARDO ROSSO.
The Golden Age. 1886.
Wax over plaster,
16⅝ × 20½ × 11″

23. ALBERT BIERSTADT.
Coast Scene (West
Indies). c. 1880–93.
Oil on paper mounted
on Masonite, 13½ × 18½″

23

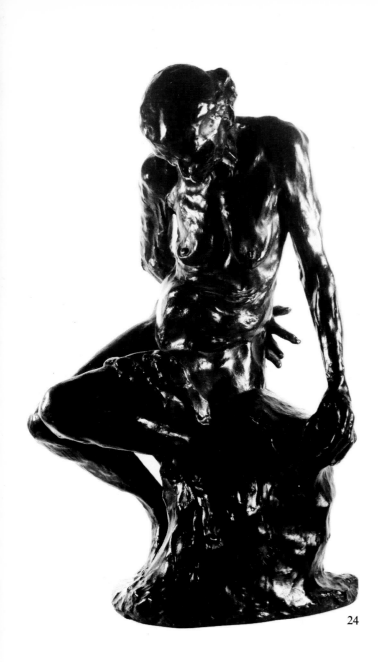

24

24. AUGUSTE RODIN.
She Who Was Once the Helmet-Maker's Beautiful Wife (The Old Courtesan).
1885. Bronze, 19⅞ × 9¼ × 12"

25. AUGUSTE RODIN.
The Burghers of Calais. 1886.
Bronze, 82½ × 95 × 78"

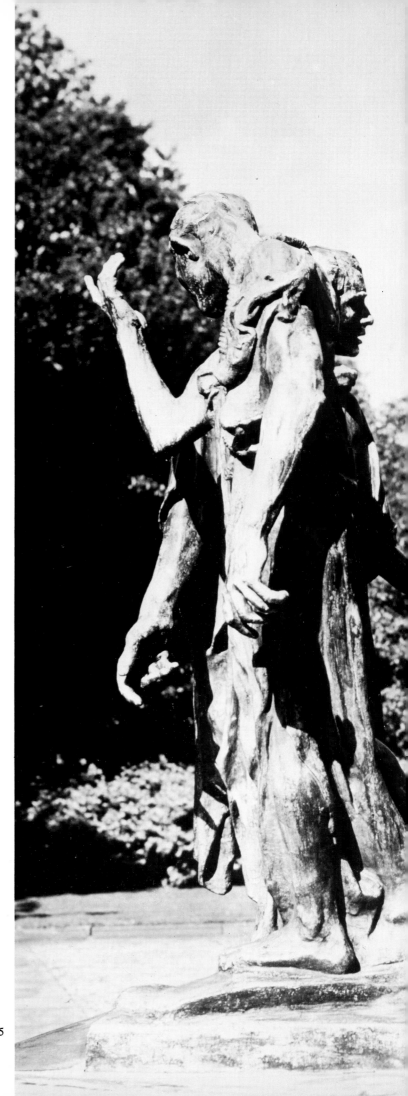

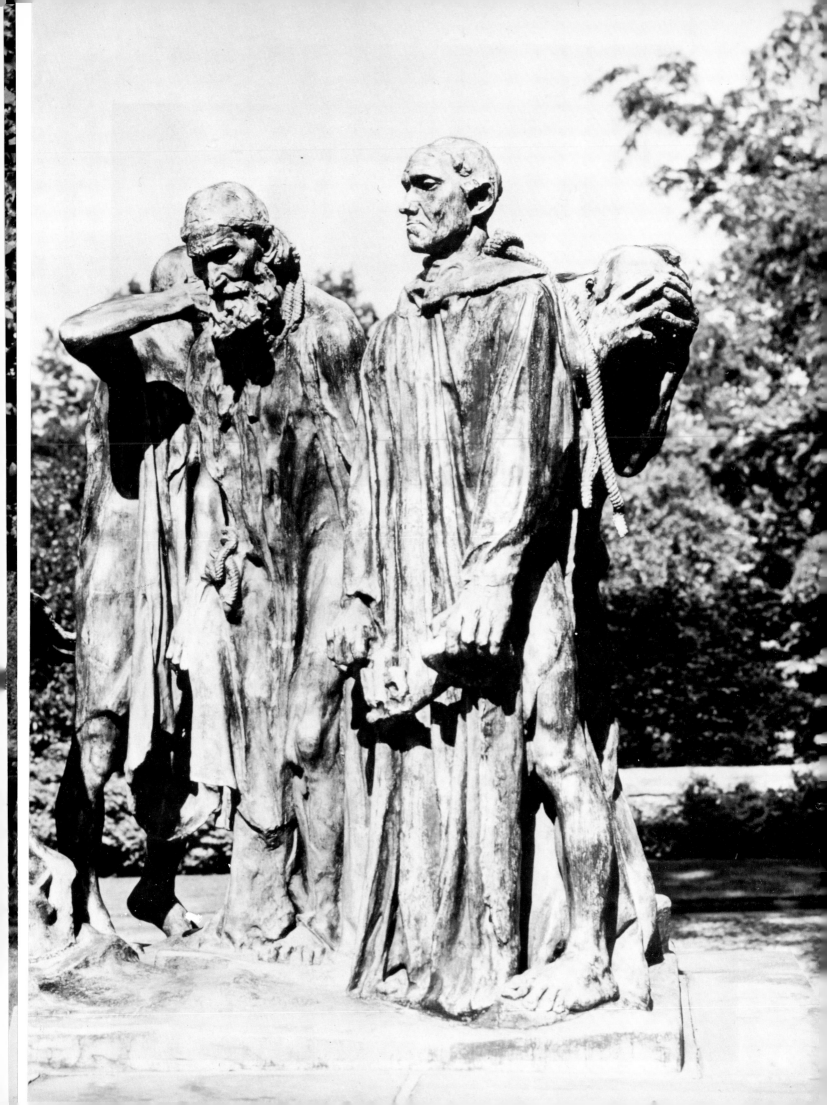

38

39

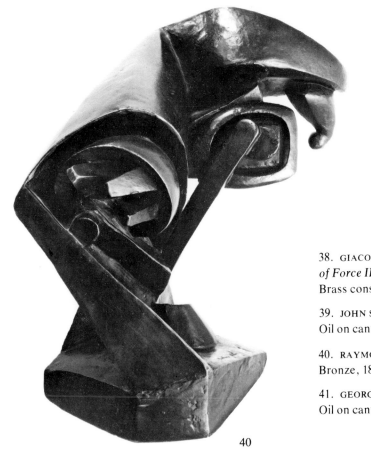

38. GIACOMO BALLA. *Boccioni's Fist—Lines of Force II*. 1915, reconstructed 1955/68. Brass construction, 31½ × 30 × 10"

39. JOHN SLOAN. *Carmine Theater*. 1912. Oil on canvas, 25 × 31"

40. RAYMOND DUCHAMP-VILLON. *Horse*. 1914. Bronze, 18¼ × 18½ × 8½"

41. GEORGE BELLOWS. *The Sea*. 1911. Oil on canvas, 33 × 44"

40

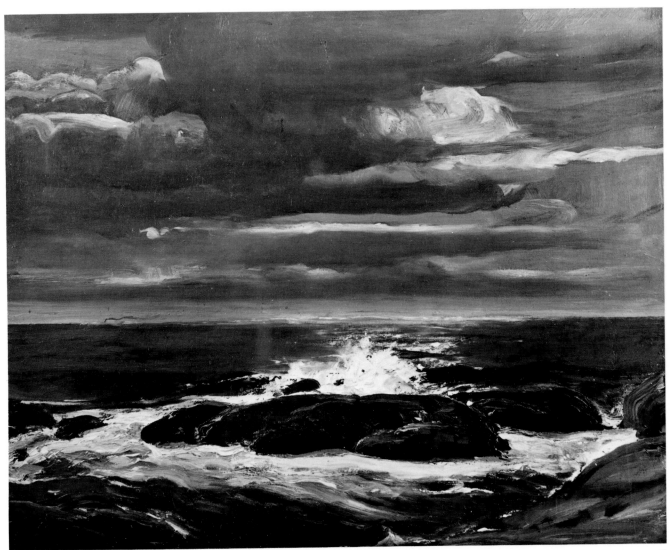

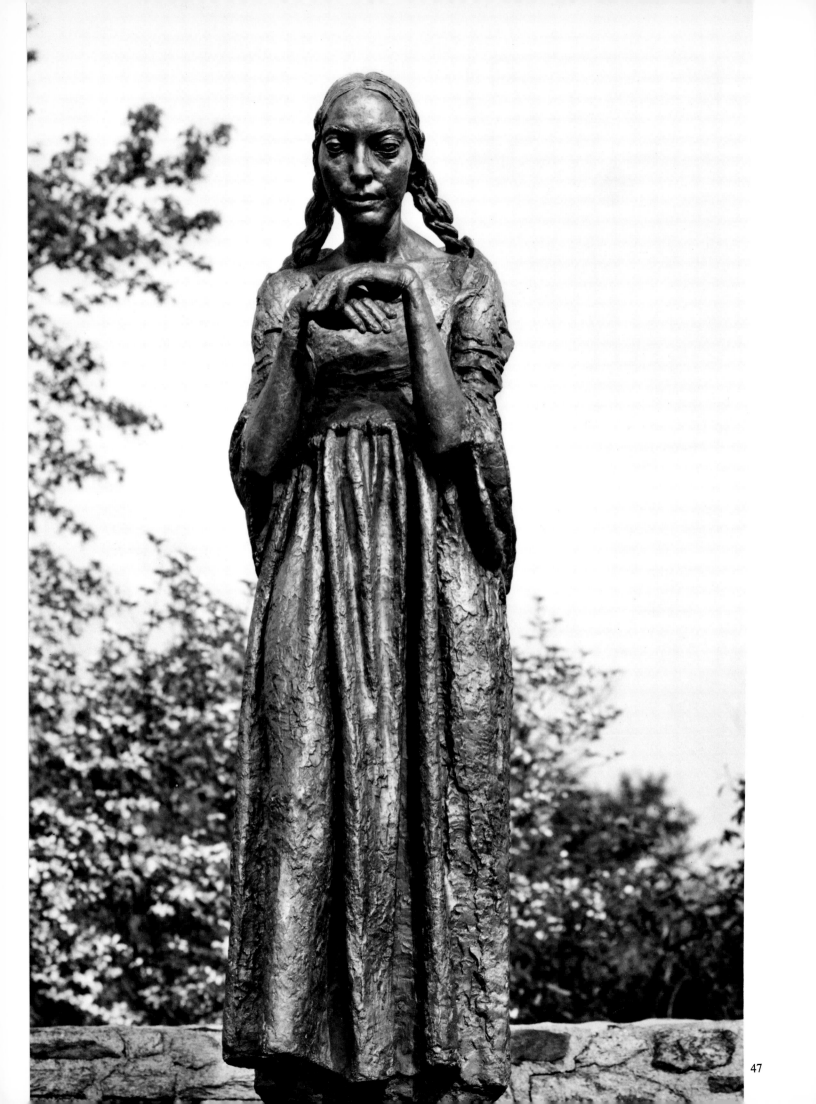

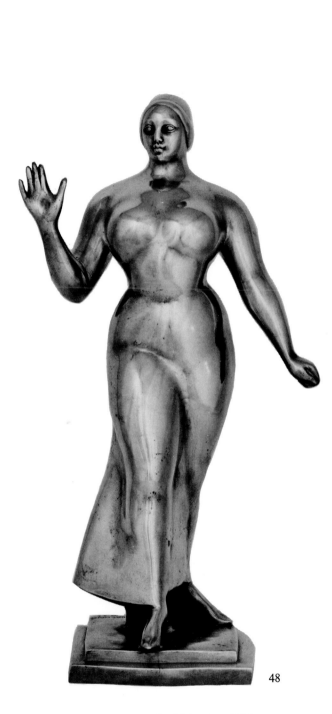

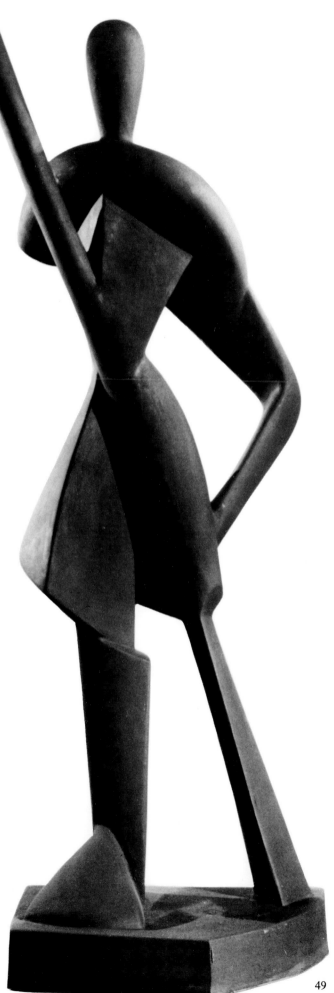

47. SIR JACOB EPSTEIN. *The Visitation.* 1926,
cast 1955. Bronze, 66 × 19 × 17½"

48. GASTON LACHAISE. *Walking Woman.* 1919.
Bronze, 17 × 10¾ × 7½"

49. ALEXANDER ARCHIPENKO. *Gondolier.* 1914,
reconstructed c. 1950, enlarged and
cast 1957. Bronze, 64 × 26 × 16"

48

49

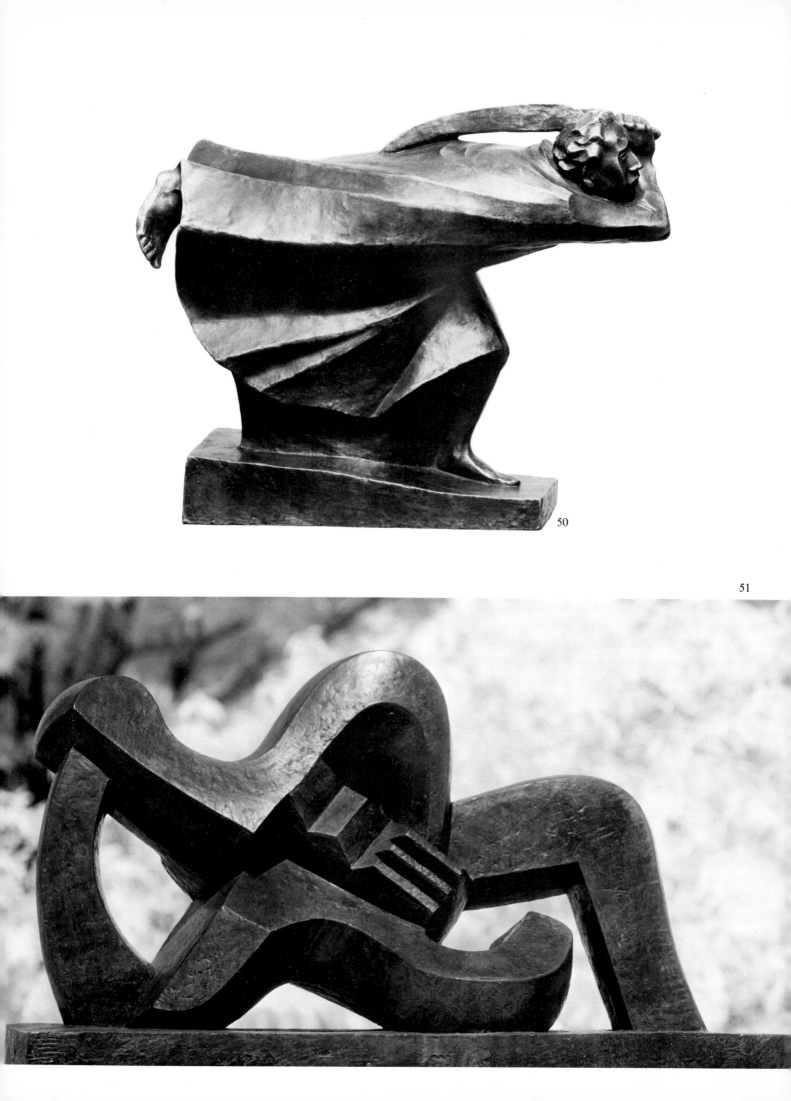

50

51

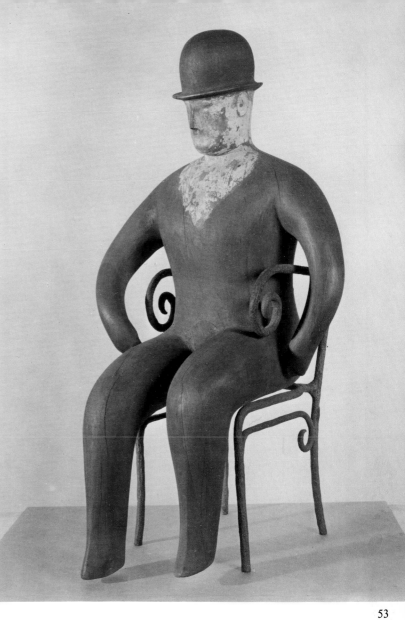

53

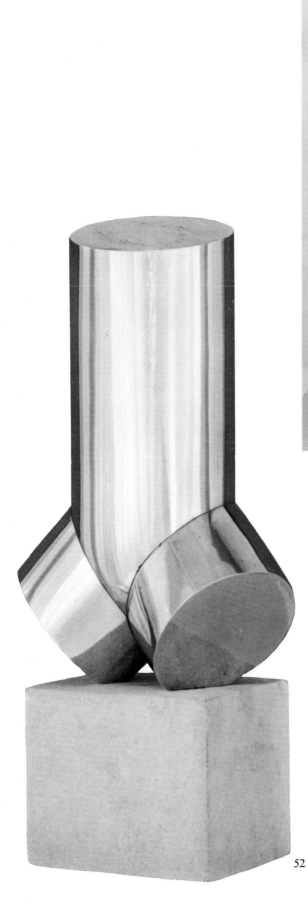

52

50. ERNST BARLACH.
The Avenger. 1914.
Bronze, 17¼ × 23 × 8¼″

51. JACQUES LIPCHITZ.
Reclining Nude with Guitar. 1928.
Bronze, 16 × 29¾ × 13″

52. CONSTANTIN BRANCUSI.
Torso of a Young Man. 1924.
Polished bronze on original
stone and wood base, 18 × 11 × 7″;
height of base 40⅜″

53. ELIE NADELMAN.
Host. c. 1920–23. Painted cherry
wood and iron, 28⅞ × 15½ × 14½″

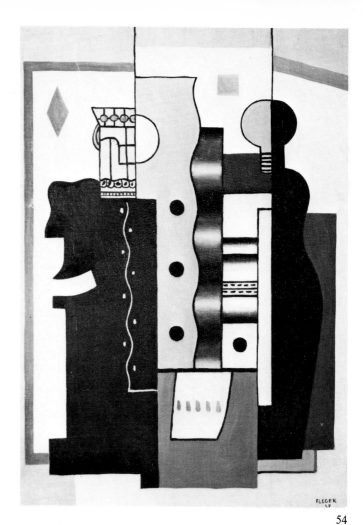

54. FERNAND LÉGER.
Still Life, King of Diamonds.
1927. Oil on canvas, 36 × 26″

55. PATRICK HENRY BRUCE.
Forms #12. 1927.
Oil on canvas, 35 × 45¾″

56. ROBERT DELAUNAY.
Study for *Portrait of*
Philippe Soupault. 1922.
Watercolor and black chalk on
paper mounted on canvas, 76½ × 51″

54

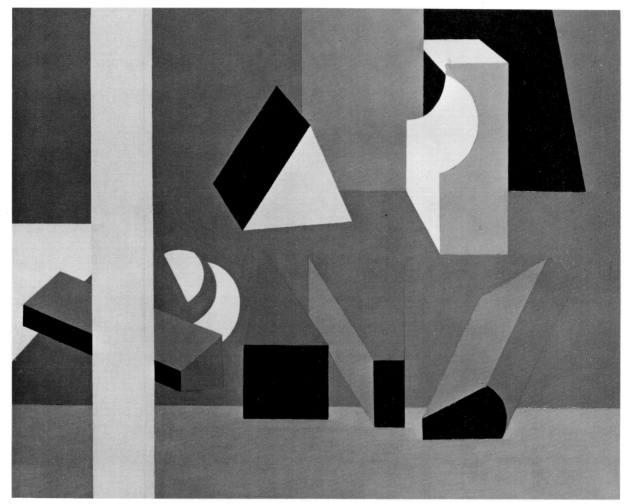

55

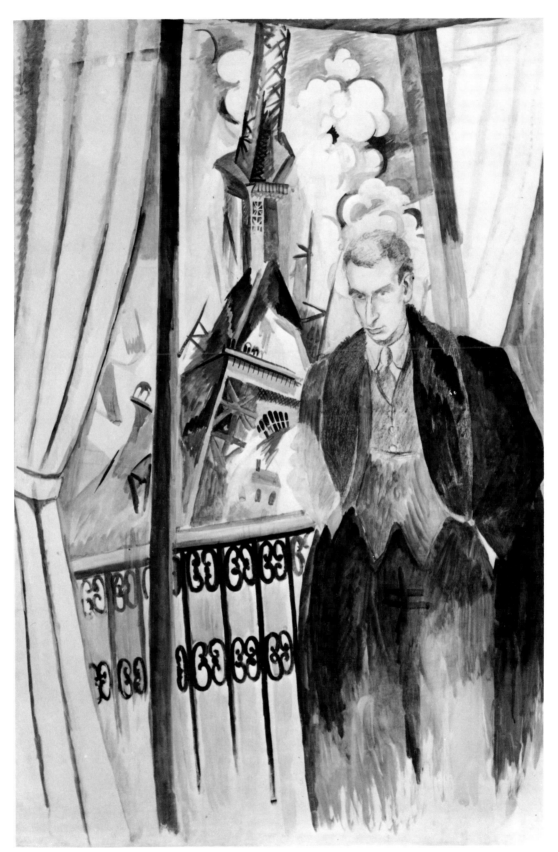

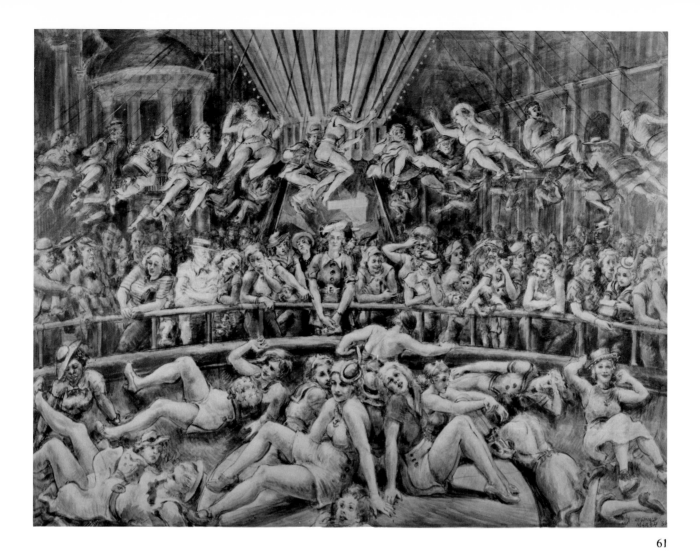

61

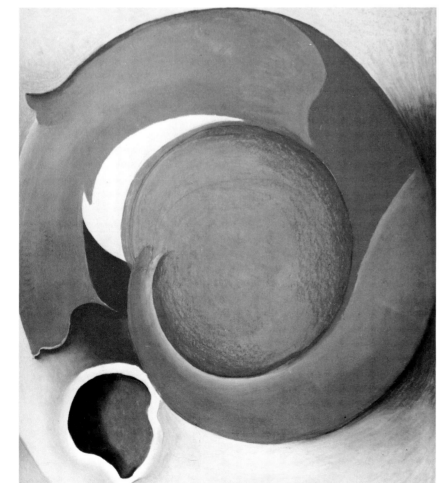

62

61. REGINALD MARSH.
*George C. Tilyou's Steeplechase
Park.* 1936. Egg tempera
on wood panel, 36 × 48″

62. GEORGIA O'KEEFFE.
Goat's Horn with Red. 1945.
Pastel on paper, 31⅜ × 27⅝″

63. ARTHUR B. CARLES.
Abstraction (Last Painting).
1936–41. Oil on board, 41¼ × 58⅜″

64. HENRI LAURENS.
Maternity. 1932.
Bronze, 21 × 55 × 23″

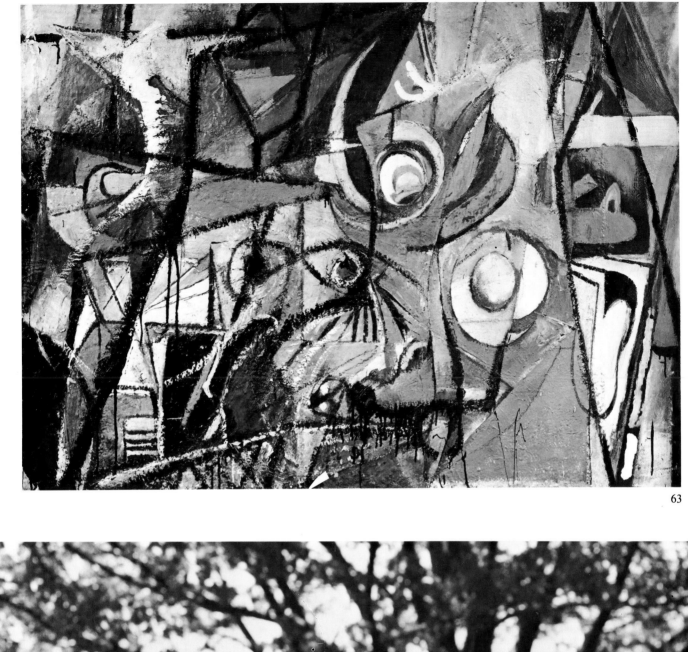

63

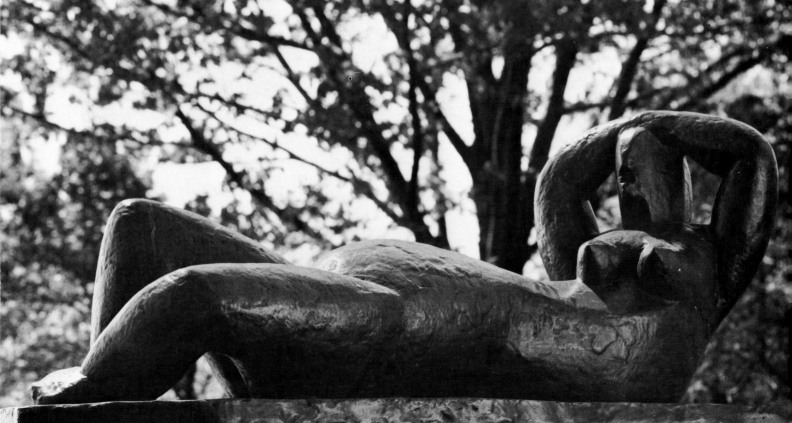

64

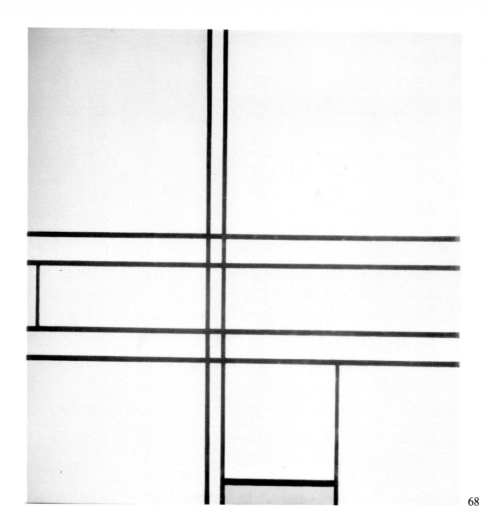

68

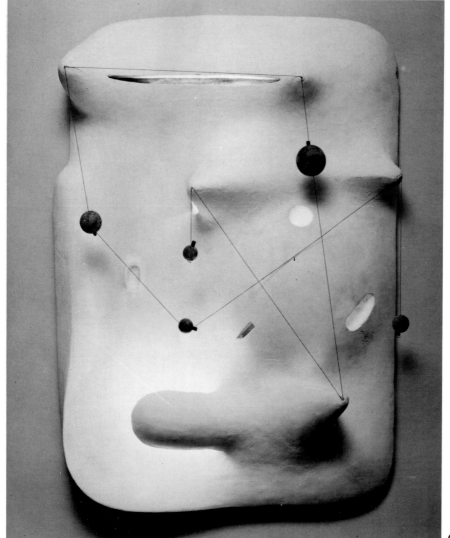

68. PIET MONDRIAN.
*Composition with Blue
and Yellow*. 1935.
Oil on canvas, 28½ × 27¼″

69. ISAMU NOGUCHI.
Lunar Landscape. c. 1944.
Magnesite cement, cork,
fishing line, and electric
lights, 33¼ × 24 × 7″

70. HORACE PIPPIN.
Holy Mountain III. 1945.
Oil on canvas, 25 × 30″

71. YVES TANGUY.
The Doubter. 1937.
Oil on canvas, 23¾ × 32″

69

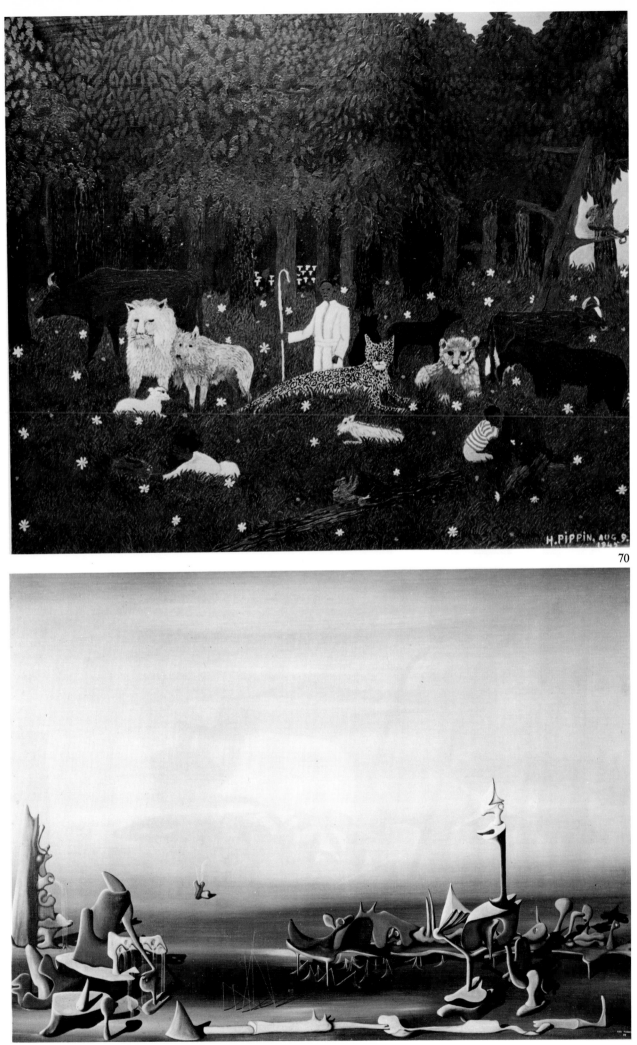

70

71

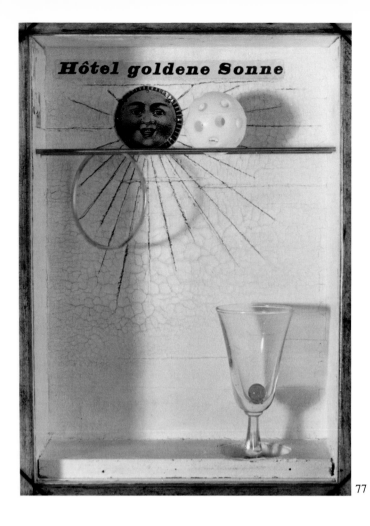

77

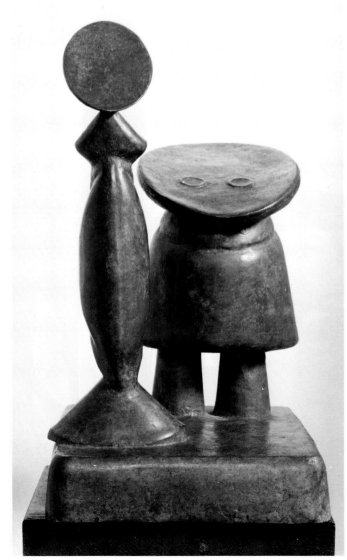

78

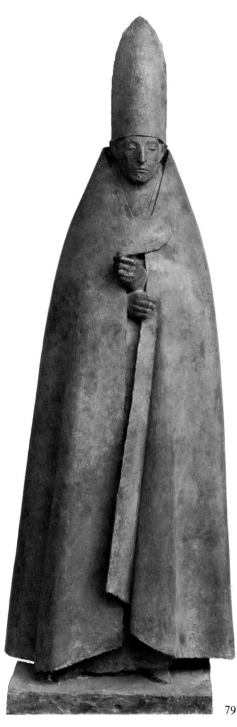

79

77. JOSEPH CORNELL. *Hôtel goldene Sonne.*
c. 1955–57. Box construction, 12⅞ × 9½ × 4″

78. MAX ERNST. *Daughter and Mother.*
1959. Bronze, 17⅝ × 10⅜ × 11½″

79. GIACOMO MANZÙ. *Large Standing Cardinal.*
1954. Bronze, 66½ × 23 × 15¾″

80. FRANCIS BACON. Study for *Portrait V.*
1953. Oil on canvas, 60 × 46″

81. RAPHAEL SOYER. *Farewell to Lincoln
Square* (Pedestrians). 1959. Oil on canvas, 60¼ × 55″

82. HENRY MOORE. *Upright Motive No. 1:
Glenkiln Cross.* 1955–56. Bronze, 11′ × 3′ × 3′2″

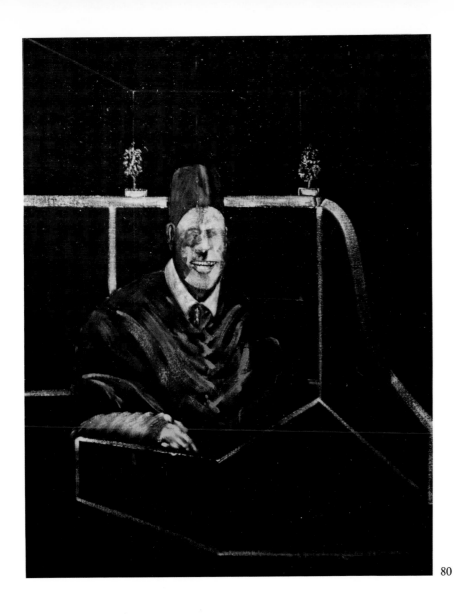

80

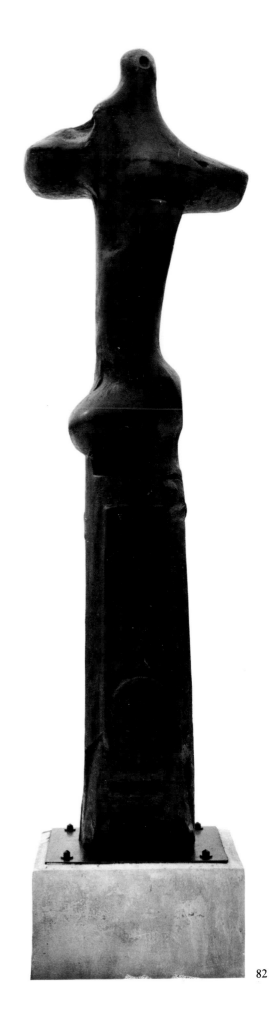

82

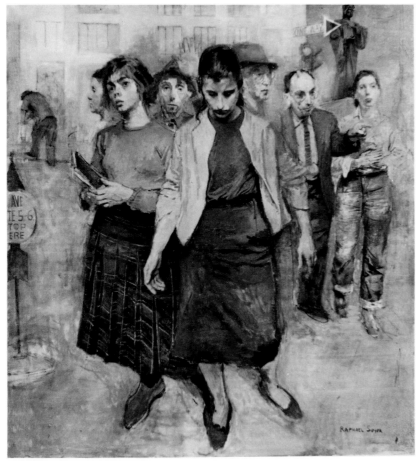

81

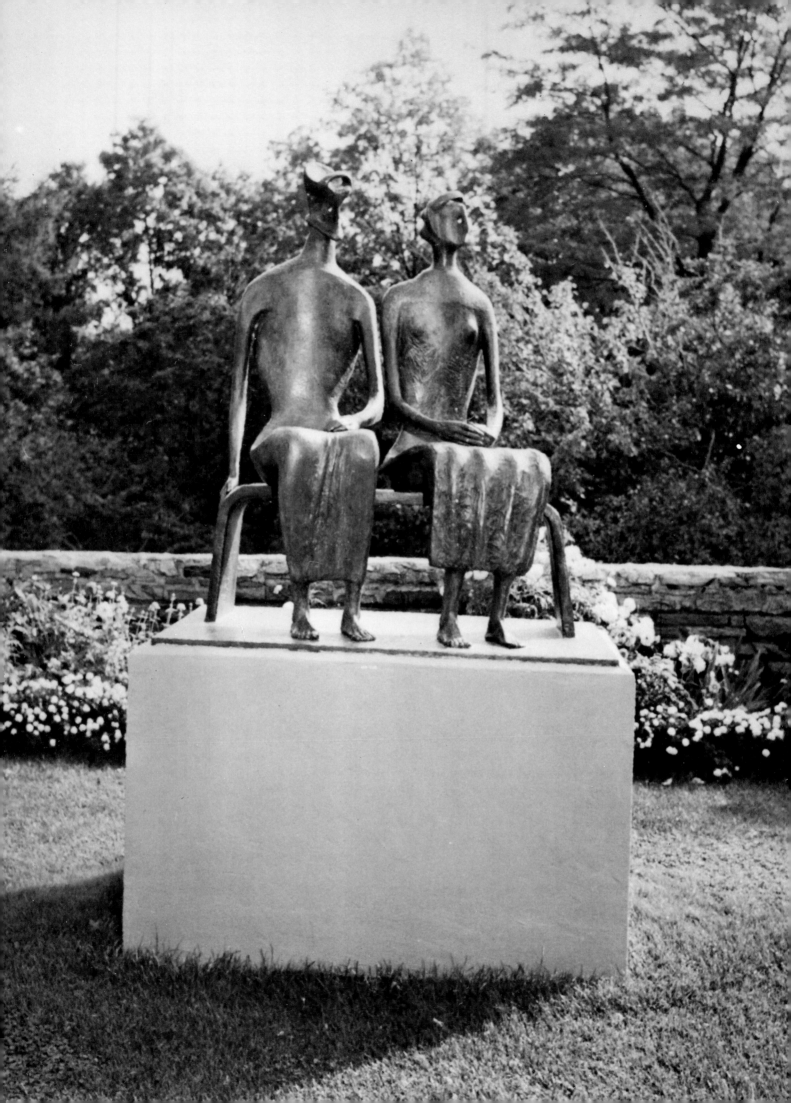

83. HENRY MOORE. *King and Queen*. 1952–53. Bronze, 63½ × 59 × 37½"

84. NAUM GABO. *Linear Construction No. 2* (smaller version). 1949. Plastic construction with nylon thread, 15 × 11 × 11"

85. JEAN ARP. *Human Lunar Spectral* (Torso of a Giant). 1957. Bronze, 45 × 32 × 26"

86. DAME BARBARA HEPWORTH. *Pendour*. 1947. Painted wood, 10⅜ × 27¼ × 9"

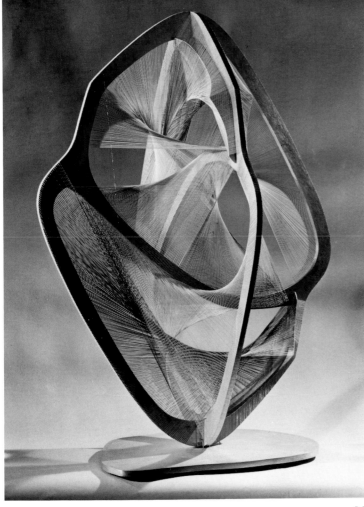

84

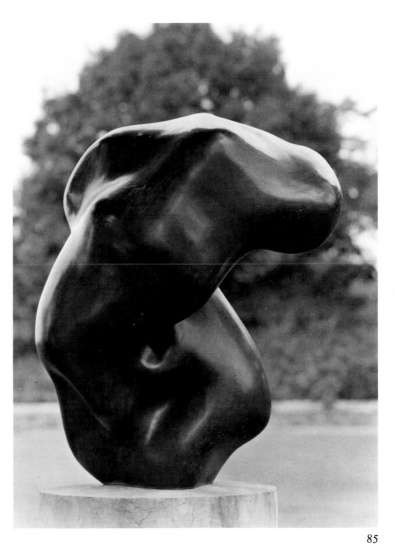

85

◀ 83

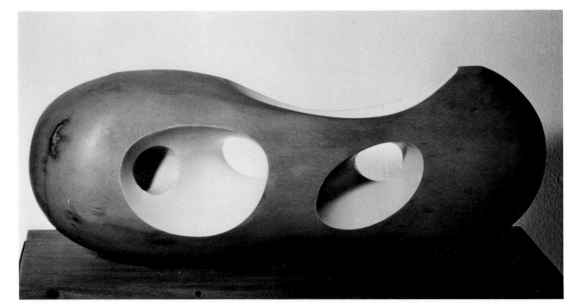

86

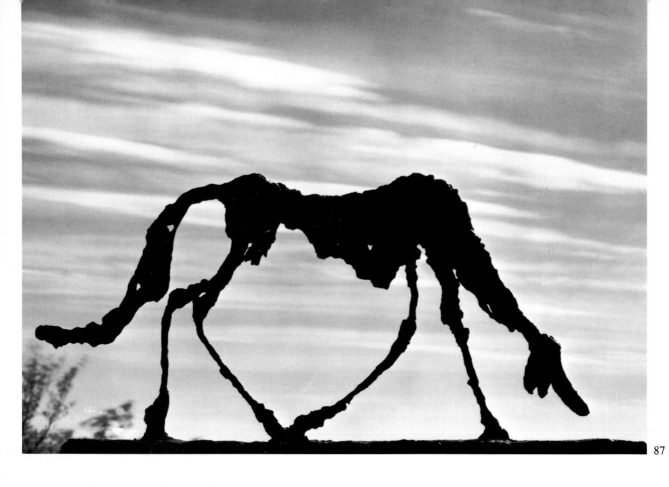

87

88

89

87. ALBERTO GIACOMETTI.
Dog. 1951, cast 1957.
Bronze, 17¼ × 36¼ × 6⅛″

88. FRANZ KLINE.
Delaware Gap. 1958.
Oil on canvas, 6′6″ × 8′10″

89. ROBERT MOTHERWELL.
Black and White Plus Passion. 1958.
Oil on canvas, 50 × 80″

90. ANTOINE PEVSNER.
Column of Peace. 1954.
Bronze, 52 × 33 × 17¼″

90

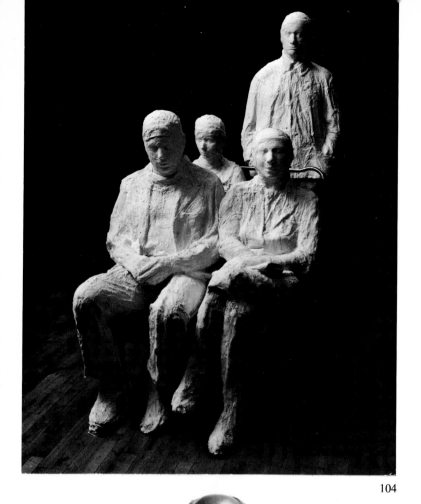

104

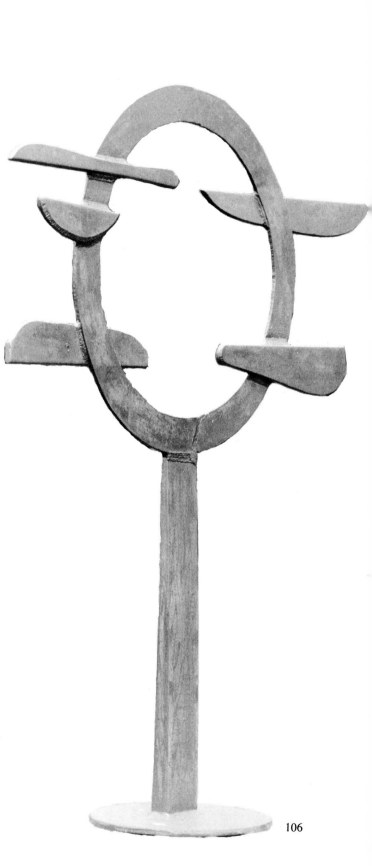

106

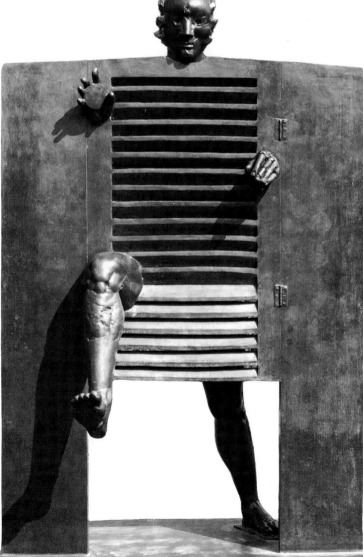

105

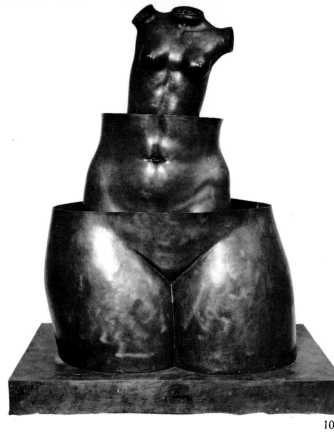

107

104. GEORGE SEGAL. *Bus Riders*. 1964.
Plaster, metal, and vinyl, 69 × 40 × 76″

105. JEAN IPOUSTÉGUY. *Man Pushing the Door*.
1966. Bronze, 77½ × 51 × 46″

106. DAVID SMITH. *Voltri XV*. 1962.
Steel, 90 × 77 × 2½″

107. RENÉ MAGRITTE. *Delusions of Grandeur*. 1967.
Bronze, 61½ × 48 × 32½″

108. JOAN MIRÓ. *Lunar Bird*. 1966.
Bronze, 90⅛ × 81¼ × 59⅛″

108

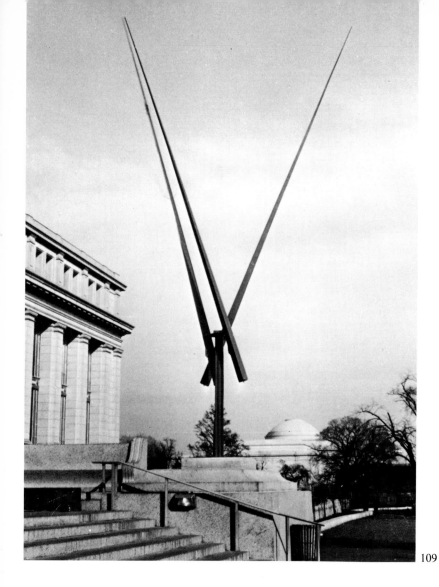

109

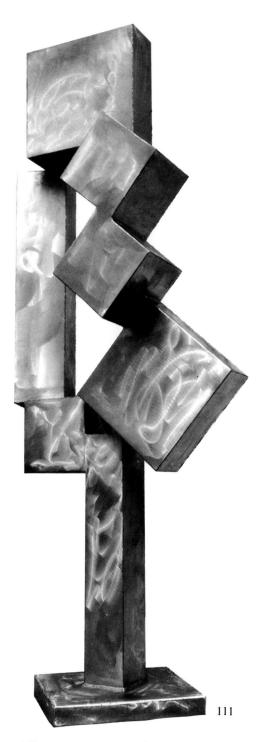

111

110

109. GEORGE RICKEY. *Three Red Lines.*
1966. Lacquered stainless steel
kinetic construction, height 37′

110. MARK DI SUVERO. *The "A" Train.* 1965.
Wood and painted steel, 13′ × 11′11″ × 9′7″

111. DAVID SMITH. *Cubi XII.* 1963.
Stainless steel, 9′1½″ × 4′1″ × 2′2″

112. KENNETH SNELSON. *Lorraine* (Crane
Booms). 1968. Painted steel and stainless
steel cable, 11′9″ × 16′10″ × 17′2″

113. ALEXANDER CALDER. *Two Discs.* 1965.
Painted steel plate, 25′6″ × 27′4″ × 17′4″

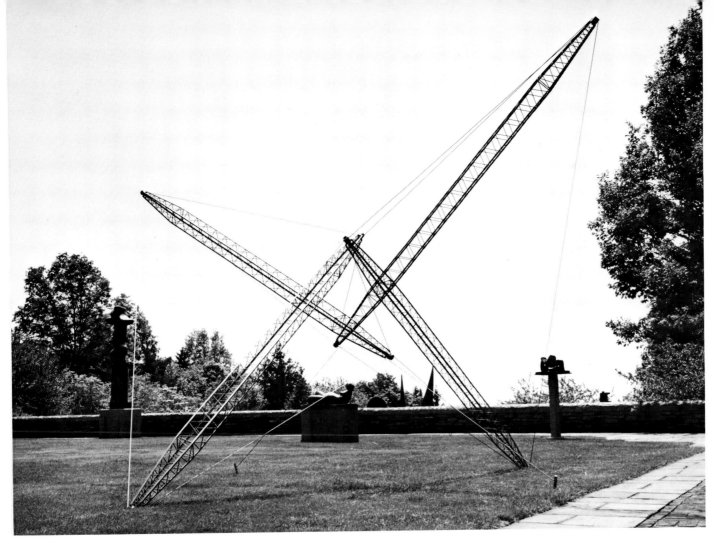

112

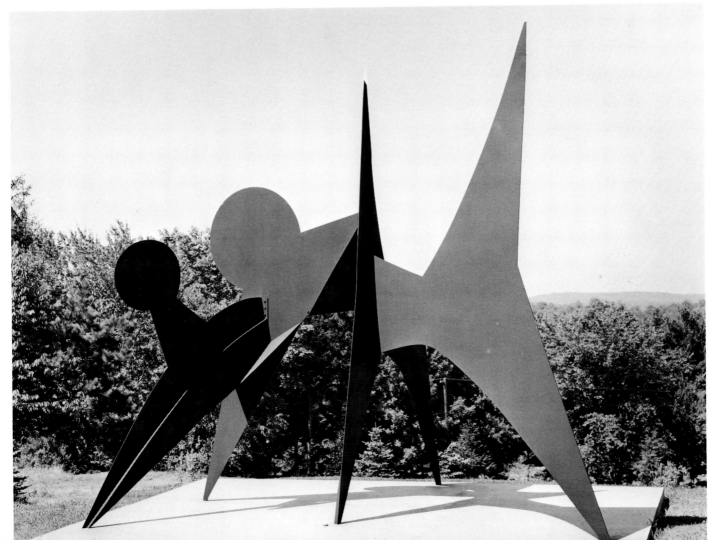

113

114. KENNETH NOLAND.
Bend Sinister. 1964.
Acrylic on canvas, 7'8¾" × 13'5¾"

115. JASPER JOHNS.
Numbers 0 to 9. 1961.
Oil on canvas, 54 × 41⅜"

116. JESUS RAFAEL SOTO.
Two Volumes in the Virtual. 1968.
Painted metal, Masonite, and
wood, 9'10½" × 6'6¾" × 6'6¾"

117. ROY LICHTENSTEIN.
Modern Painting with Clef. 1967.
Oil and acrylic on canvas, 8'4" × 15'

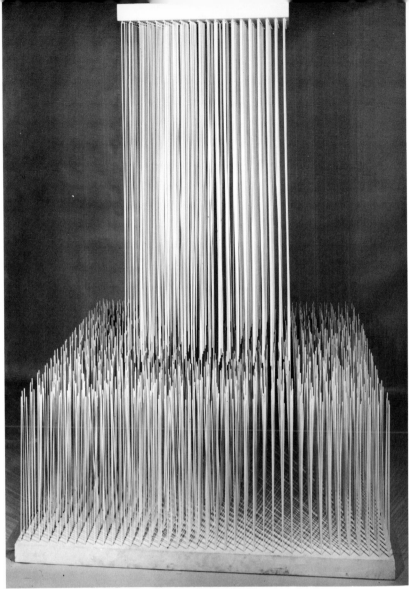

116

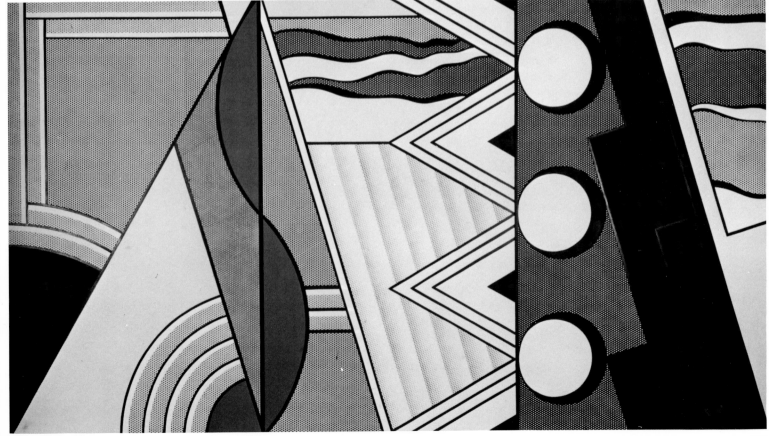

117

List of Plates